VOICES

14 + 1 ARTIST HEROINES SPEAK THEIR CREATIVE JOURNEYS

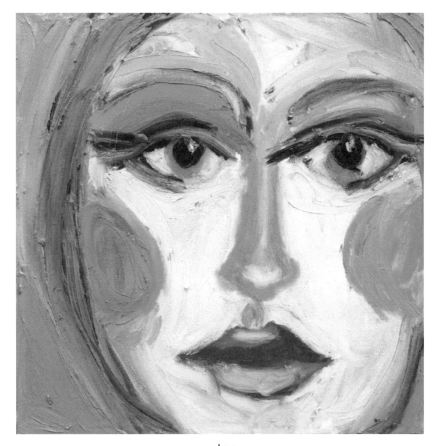

by
Vicki Todd

Balboa Press books may be ordered through booksellers or by contacting:

Balboa Press
A Division of Hay House
1663 Liberty Drive
Bloomington, IN 47403
www.balboapress.com
1 (877) 407-4847

Because of the dynamic nature of the Internet, any web addresses or links contained in this book may have changed since publication and may no longer be valid. The views expressed in this work are solely those of the author and do not necessarily reflect the views of the publisher, and the publisher hereby disclaims any responsibility for them.

Any people depicted in stock imagery provided by Getty Images are models, and such images are being used for illustrative purposes only. Certain stock imagery © Getty Images.

ISBN: 978-1-9822-0677-2 (sc)
ISBN: 978-1-9822-0676-5 (e)

Library of Congress Control Number: 2018908546

Print information available on the last page.

Balboa Press rev. date: 08/28/2018

BALBOA.
PRESS
A DIVISION OF HAY HOUSE

Also by Vicki Todd:

Unstuck: One Heroine's Journey of Art and the Courage to Live on Purpose

Floater No More: How the Courage to Walk through an Open Door Changed Everything, a chapter in *20 Beautiful Women Volume 2: 20 More Stories that Will Heal Your Soul, Ignite Your Passion, and Inspire Your Divine Purpose*

This book is dedicated to all the Wild Woman Creatives who cannot resist dancing to the drumbeat of their soul's passions.

"It's on the strength of observation and reflection that one finds a way. So, we must dig and delve unceasingly."

—Claude Monet

Foreword

"I've been absolutely terrified every moment of my life – and I've never let it keep me from doing a single thing I wanted to do." —*Georgia O'Keeffe*

Having spent the last fifty one years of one's life in the business of creating and marketing fine art and helping others to do the same, it is reassuring to see someone else taking the reins in making the effort to help other like-minded creative people. People in all walks of life intend to do great things for their fellow man, but few ever really rise to the opportunity.

Every once in a while though, I am surprised to find someone that actually succeeds.

That is not to say there are not good and even great visual artists out there making their way to success. There are, and a lot of them too, but few remember to keep their promise to themselves to help their fellow constituents just getting started or those in an extended effort, but got lost on their way.

I've experienced that myself. After selling thirteen hundred paintings, making over thirty-two thousand drawings, and participating in over four hundred public exhibitions of my work, I can easily relate to some of the things you will find in *Voices*.

The author, Vicki Todd, is one of those that makes the rest of us both jealous and excited that she has achieved this success. Here, she has gathered the achievements, the success stories of fourteen of her fellow female artists and found the commonality that brings them to be what they are, what they have achieved. Each has her own trials and rewards that brought her to be the person she is today. Vicki Todd has gathered their stories together here so that we all may see that those successes are possible.

Hard work, perseverance and an enthusiasm to achieve have made them all worthy to be represented on these pages. These and the struggle to understand and appreciate themselves are a common thread among the stories that describe their successes.

Dorothee Chabas an oil painter and neurologist says, "I don't believe you need to be miserable and tortured to be a good artist. You can be a serious artist and have a balanced, happy life." She is correct in her assessment. That doesn't mean that hard work and perseverance are not key to success. They are and it is obvious in remarks written by the other thirteen artists included in this book.

"An artist whose work may not be the best," writes Lorie Hoffman, "but they are committed to finding the right

target audience for their work, will win out every time versus a talented artist who is not willing to effectively market their work."

The author and collaborator has brought together the evidence that creative achievement is not an accident. Along with her female associates, the unique perspective the author uses to complete her book is uncommon in the self-help motivational genre. Jacqueline Calladine, textile maker, writes that, "I've learned it's OK to tap into your creative community and ask other artists for help." The writing in this book is a testament to that idea.

Collaborating with these artists, Vicki Todd is showing us that it is not just talent. In fact it is way more than that. Reading about the effort each of these women has made to make the future their own, tells us it is about people, personalities and understanding. Not only is it not easy, but the effort is definitely worth the time. Reading what these fourteen plus one artists have to say is surely the encouragement many more artists, still in the closet, need. Their trials and successes make us realize, we can do it too.

Vicki Todd knew what she was doing when she collected these fourteen artist heroines together for her book. Having an EdD in Higher Education and teaching public relations as an assistant professor at Quinnipiac University, her book reveals those previous experiences allowed her to understand, to be in tune with, the effort and enthusiasm required to succeed. Today, her chosen field as an artist painting her ubiquitous faces has lead her to right now, finding the courage to perform as every artist must. The urge to perform is not a reliable sign of talent. Artists must always produce the product of their thinking.

Vicki Todd not only produces her own fine memoir portraits, but helps others help themselves find their place as artists. She teaches *Paint Your True Selfie Portrait*, a structured workshop enticing the student to discover "Who am I." She has a twice monthly radio talk show, *Unstuck JOY!,* and is a motivational author. Her first book, *Unstuck: One Heroine's Journey of Art and the Courage to Live on Purpose*, earned her a Kirkus Review. The reviewer recognized Ms. Todd's insightful work when he said, "Todd's paintings give the book a unique angle on the realizing-your-purpose genre."

As the author of *Voices*, Vicki Todd, confides, "The legacy I hope to leave is by having the courage to shine my light and use my gifts, others will be inspired to do the same."

John Weidenhamer • *Artist*
Indio, California

Preface

A thread runs through it.

After telling the story of my own winding artistic path in my visual memoir, *Unstuck: One Heroine's Journey of Art and the Courage to Live on Purpose*, I had the desire to ask other female creatives about their unique Heroines' Journeys.

So, I embarked on a new quest of discovery, mining the mountains and valleys of women who have made their passion for art their professional careers. Since I had recently moved from the Northeast to the Pacific Northwest, I began by inviting a handful of female artists I met in my new creative community. But, where could I find more artists to complete the Voices project?

Enter stage right: Crista Cloutier, creator of The Working Artist online class, which I had taken several months prior. Crista hosted a Magic Circle in Seattle. We connected, and I told her about the Voices project. She graciously invited me to post an artist call on The Working Artist social network.

I set the intention for the Universe to send the appropriate number of female artists who matched the book's purpose and vision. As usual the Universe didn't disappoint.

Voices relays the compelling stories of 14 female artists who have bravely allowed the gifts with which they were born to shine and greatly benefit the world. (My own story is the +1 in Voices.)

The Voices artists include painters – acrylic, mixed media, oil, watercolor – a decorative plaster artisan, a hand-weaver, a screen-printer, a sculptor, and a textile maker. They are of a range of ages. Some hold art degrees, and some are self-taught artists. They come from Australia, Canada, England, France, New Zealand, Thailand, and the US. I asked each one the same eight questions loosely based on Joseph Campbell's Hero's Journey: What was your first experience of knowing your True Self is an artist? What has been your greatest fear, struggle or resistance along your journey of becoming an artist? How do you overcome your Inner Critic, limiting beliefs, and other creative obstacles? Who are/were your greatest encouragers who nurtured your gift, and how do/did they support you? What most influences your work – in other words, what is your Muse? What does your creative process look like? What advice would you give those coming behind you? What is the legacy you hope to leave when you exit this Earth?

What can you expect to glean from the Voices stories, dear Reader? That even though the contexts and details of the stories differ, common themes run through each journey: believing it's never too late to begin again/create,

knowing that your life's purpose will continue to resurface and tap you on the shoulder until you accept your calling, overcoming obstacles and resistance from self and others, persevering, surrendering.

I humbly thank each artist for entrusting your personal stories with me for the Voices project. You are Wild Woman Spirits who inspire us all with your bravery to create beauty and meaning in this crazy world. I thank John Weidenhamer, the artist who graciously wrote the beautiful foreword for an artist chick he'd only met through a series of rollicking phone conversations. Thank you to Crista Cloutier for allowing me to access The Working Artist network to find talented artists for the book. And, thank you to VALA Eastside, a nonprofit art center in Redmond, WA, for the opportunity to connect with a creative community of artists who are in Voices.

As you read each story in Voices, I hope you find inspiration to evolve on your own Hero/Heroine's Journey. The world needs you to shine your unique Light!

Jacqueline Calladine
Textile Maker

I've struggled with the word "artist." I'm more of a maker. I think I've always known that's who I am. I have a picture of me at 2 years old in our backyard in England in the garden, and I'm pulling off the petals of all my dad's flowers, which I always did. I'm not that different now to that girl. I'm still pulling petals and plants up and using them to create art, and I've done that since I could handle a pencil.

My main creative blockages have been about demystifying the self-imposed barriers along my path. When I moved from the UK to the US, I thought that my art life in Britain would disappear. For a long time, I kept myself very small-minded, thinking, "I could never do that. Who am I to think I could do that?" I gradually realized it's just another challenge I must figure out how to navigate. The process of learning how to ship my work and exhibit in two countries pushed me to extend the edges of my comfort zone. I've learned it's OK to tap into your creative community and ask other artists for help.

How do I find a connection with this land that isn't my own land? All of my work is influenced by finding a connection between places, and that's become stronger since I moved from the UK to the US. It's intuitive residual memory work. I've been doing a lot of abstract drawing, and the marks look like some kind of a map or a landscape. I've discovered they're little snippets of different memories that all come together into one. It might be a childhood memory of a field of poppies where I used to live in the UK, but that might get mixed up with the view of a hiking trail in Washington State. They compel me to ask, "What is home? Is it somewhere that's in my heart or a geographical location?"

Walking the same nature trail is part of my process. I record the plants I see through photography and writing. I forage berries, flowers and leaves and boil them to extract the color or put the plant material directly on cloth. I then roll the cloth and steam it, or I'll leave it outside in the sun for a few weeks. Some of the cloth gets buried in my backyard, or I might hide it somewhere in a river or on the hiking trail, and observe to see how it evolves over time. I replicate this weathering process with a piece of cloth to build up the layers, colors and textures until it's got the complexity I desire. I create most of my work in the summer, and a little bit in the fall, when the berries and flowers are in season. It's important to me to not harm the earth; I want to tread lightly. I want everything I make to disappear and to compost eventually.

I can hear you, but not today. I sketched an Inner Critic Bug. Sometimes while I'm working, I have him out with his horrified face saying, "Ah, no! What are you doing Jacqui?" And I just talk to it; I think humor can overcome fear. I see him as my protector. It's safer if I don't make the work, and I don't try to sell it. But what's the risk? I

just become that little, horrified person who is too scared to do anything. The risk is I'm not expressing all those ideas I have in my mind, and that's more powerful than the little bug, ultimately.

My greatest encourager was my grandmother, who was a painter. She showed me that art can be part of my daily life. The back room of her house, which was the dining room where no one ever ate, was her studio. Her oil paints were always on the table, and that smell of oil paint still brings back those memories to me now.

Sometimes the people who question your work can shift your practice in a positive way. I taught a textile workshop in the 1990s when the industry didn't favor natural dyes. A lady in the audience asked why I used chemical dyes when I proclaimed to value eco practices and saving the Earth. I couldn't answer her question beyond, "That's what I was taught in school." This compelled me to learn how to develop plant-based dyes that matched my personal values. I had to acclimate to creating my art at a slower pace that revolves around the seasons. I also discovered that I couldn't easily replicate colors as with chemical dyes.

When people are negative about your work, it makes you think, "Well maybe they're right," and you change it. Or sometimes it can reinforce that you're on the right path, and you create with more strength, because you've gone through an evaluation process. The key is to listen to criticism with emotional distance.

My advice to aspiring creatives is to go at your own pace and don't compare yourself to other artists' output or accomplishments. Learn how your energy pattern works. Develop a strong practice, whatever that looks like to you, whether it's creating every day, once a week, once a month, or like I do in that confined period of three months every year. Allow your dream to evolve.

The legacy I want to leave behind is my Wild Creative Life community. It may be a community, a book, a movement, or a foundation. I would like that work to survive as support for other creatives, especially women. I think we struggle the most with manifesting our dreams. With textile work, there's a strong tradition of women coming together to create through sewing bees and quilting circles. I continue that legacy by holding creative circles at my home every quarter and season, along with an online course each season. I would like for women around the world to hold their own Wild Creative Life circles. I can teach them that structure, so they can develop their own creative communities with their unique twist.

www.jkcalladine.com

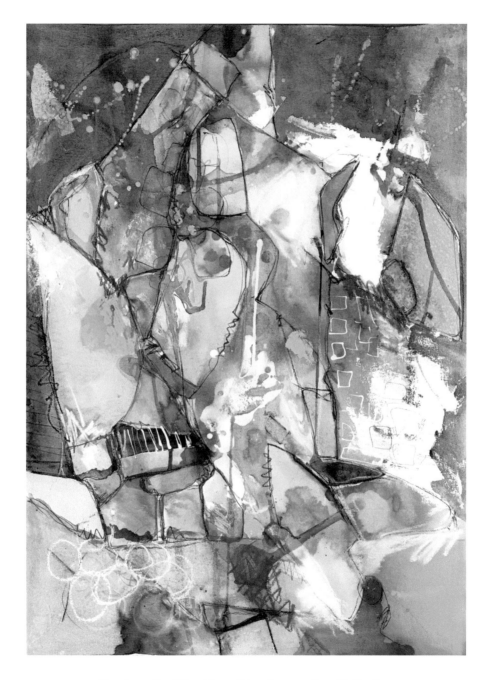

"Lost on the Way Home" by **Jacqueline Calladine**

Dorothee Chabas
Oil Painter & Neurologist

I wanted to take a picture with my eyes. I've always known I have an affinity for visual language. As a child sitting in the back seat of my parents' car driving on vacation in France, I'd look at the mountains, fields on the side of the highway, the sky and landscape. I'd try to memorize every shape, line and color. Is that mountain violet or blue? Is there a line between the sky and mountain, or are there only two blocks of contrasting colors? However, I never considered becoming a professional artist. Instead, I excelled in science in school and wanted to become a physician.

Still, I continued to love art and took live model painting workshops while attending medical school in France. I earned an MD, specialized in neurology, then earned a PhD in immunology. I specialized in multiple sclerosis, and did a postdoctoral fellowship on an animal model of multiple sclerosis at Stanford University in California. I returned to France to continue my career as a neurologist in academia, including clinical, teaching and research activities. It was challenging as a female in the French male-driven neurologist arena. After four years, I returned to San Francisco with my husband and children and obtained my California medical license. I co-created the Regional Pediatric Multiple Sclerosis Center at the University of California, San Francisco. Simultaneously, I took life drawing workshops at the Sharon Art Studio. After four years, exhausted by work obligations plus raising a family, I became disillusioned with jumping through more hoops for the next grant, the next promotion, the next research project. I also felt I was missing out in other areas of my life, such as my family and creativity.

As a neurologist, I never saw a dying person who told me they wished they had spent more time at work - never. At the age of 41, I made the big jump: I quit my job as a physician and began to ask myself the big questions. "You accomplished all these things. Now, what do you really want to do?" I wanted to develop myself in a dimension other than academia or motherhood. Eventually, I decided to switch to painting full time. It was a tough decision, because it meant redefining my work identity, which was so closely tied with my personal identity. Although I didn't know what being a "real" artist meant, I enrolled in the San Francisco Studio School, which caters to students who are advanced artists, so I didn't have to begin from scratch. The end goal was less clear than when I started medicine, but I felt full of energy, hopes and expectations.

I received a variety of responses from people when I stepped away from my medical career, ranging from, "Are you sure you're OK?" to "Congratulations!" But my mind was set: I wanted to explore the world again like I had as a child sitting in the back seat of my parents' car driving on vacation. I was reconnecting with the inner 8 year old who chased grasshoppers at my grandmother's house in France's countryside. This new energy was essential to my development, yet had nothing to do with mathematics or medicine.

I'm an artist who happens to be a neurologist. I didn't deny my background as a neurologist. Rather, I progressively integrated my past history into my new life as an artist. I became interested in neuroesthetics. My neurology background allows me to understand the language of artists and put a different spin on it. My experience as a painter informs how I understand visual processing in our brain. I'm the overlap between the scientific approach and artistic perspective. I'm interested in looking at how we see.

I learned how to paint what I see, not necessarily what it is. It was liberating to learn to paint beyond the object identity of the human form, as I had experienced in live model classes. I had seen so many bodies during my medical career and knew the human anatomy so well, my mind was stuck in seeing only what was before my eyes. I gravitated toward the aliveness of flowers and trees in nature. I began abstracting them, closely observing their vibrant color, shape, movement and energy. If I see this shape, diagonal or tone in this petal or that piece of tree bark, even if it's not what another artist might see, this is what I paint from my authentic filter of the way I see.

I don't feel it's necessary to struggle through every step of your artistic career on your own. Peers and mentors can make your path easier by providing answers and feedback you wouldn't have access to otherwise. It can be a rocky road, but I don't believe you need to be miserable and tortured to be a good artist. You can be a serious artist and have a balanced, happy life.

Even if you don't pursue art as your primary career, you can use your visual approach of the world while doing many different things. In medical school, I took courses about limb anatomy and where the artery goes, whether behind or in front of the ligaments. During lectures, I sketched trees with my colored pencils. The movement of drawing gave me pleasure, but also helped me absorb the anatomy information. I'm also writing and illustrating children's books, which brings balance to my life.

I aspire to be my authentic self, live my authentic truth, walk my authentic path. I would love for my life to inspire others to be themselves, be kind, and follow what brings them joy. I hope I remain in people's minds as a person who is caring and who believes in giving instead of receiving. I haven't obtained that level of development yet, but it's what I hope to become one day. I hope people find meaning in my decision to give up medicine and become an artist. I hope I can transmit that passion and love of beauty. Art is essential to our society; it's what differentiates us from animals.

www.dorotheechabas.com
www.FairyTalesOfTheCity.com

"Flower Series #6" by **Dorothee Chabas**

Joanne Deaker

Acrylic and Mixed Media Artist

My favorite activity in kindergarten was painting; I loved drawing horses as a child. I lost that love in high school, because my school's career adviser encouraged me to pursue a "real" occupation. In New Zealand, art is seen as a hobby and not revered as a valuable career. So at university, I earned an agricultural science degree and became an animal scientist studying different feed types for growing lambs. I later studied veterinary science and worked as a veterinarian.

When I was pregnant with my first daughter, I quit my job as a veterinarian. I'd already had two miscarriages and didn't want to risk having another one. In addition, I'd become disillusioned with my work. Through this string of crises, the Universe seemed to be guiding me toward a new direction. An opportunity to join an art group appeared, along with an artistic mentor who encouraged me to begin painting again. I sold my first painting in a group exhibition the next month. I loved returning to what lit me up as a child. I knew that's what I was born to do.

Stand out and be counted. The animals I paint are not just images of cattle, horses or sheep. Sheep represent people. People tend to follow each other as sheep do. Sheep are also seen as being very similar, but they're actually not. Yes, we're all similar and connected in our human flock. Yet, we're all capable of being individuals within that flock. My paintings are first of all messages to myself, such as "stand out and be counted." But, the messages are for anyone who resonates with them and that's the power of art. I found a quote that says, "The greatest service we can provide this Earth is to be true to who we are." So by becoming an artist, I'm being true to who I am. I'm not doing my job if I'm not sharing it.

Of course, I still paint! I'm an artist. This is my job. My biggest fear is being a failure, that I'm wasting my life. It goes back to being conditioned by society that scientists and veterinarians are respected pillars of the community. The arts are seen as a hobby and being an artist isn't a "real" job. I've struggled a lot with guilt. It's expensive to earn university degrees. My husband has been very supportive financially, and he sees the value for me to have art in my life. But I do struggle with guilt, which I've experienced physically through frozen shoulders. Much of the spiritual meaning behind frozen shoulders is guilt.

I was brought up as a little girl to please other people, so it's been difficult for me to displease an awful lot of people along my journey. Some people kind of roll their eyes when they hear what I've done in the past. As an artist, you have to move on and realize it's others' limiting beliefs, not your own.

It's all in your vibration. I do a lot of inner work to release the guilt and fear I have about past decisions I've

made regarding career path, or that I allowed myself to be pressured into. I raise my vibration through meditation. I gravitate toward the Law of Attraction work of Esther Hicks and the releasing work of Hale Dwoskin. I also listen to Jeddah Mali about trusting and surrendering, and occasionally delve into Byron Katie's The Work regarding thought awareness through questioning limiting beliefs.

I've discovered that the more I work on my inner self to release negativity and raise my vibration, the less affected I am by other people's negative chatter. Others also seem to pick up on my positive vibration, so I'm less likely to be criticized from the outside the more I believe in myself. When I'm tired and I've gone back into limiting beliefs, that's when people around me can be less supportive. People tend to mirror my vibration! Walking in nature with my dog and talking with my friends also help me remain in a positive mindset.

My artwork parallels my personal spiritual journey. In the beginning, my paintings represented beautiful things that I saw. Today, my work represents the ideas behind those beautiful things. I believe images have the power to invoke joy, a smile, and to uplift people. If my work does that alone, that's great. But if my art goes a step beyond and provides a meaningful message to someone, then that reflects where I am now on my journey. It's an ongoing process; as I evolve internally, my art also evolves. Sometimes, I might feel inspired to paint something and not know why. An inner source or subconscious message emerges through an image that I might not perceive until later, or someone sees my work, and they reveal the message to me.

If I didn't paint, I would die within. I've seen so many people who haven't allowed themselves to do what they're passionate about, and their soul begins to shrivel. A woman who didn't follow her own calling for art recently bought one of my paintings. She said she identified with my passion to follow my artistic path and bought the painting because of that vibration; it comforted her.

Find your unique weave within the fabric of life. Believe in yourself, and do all you can to raise your vibration. This will persuade others to believe in you as well. Believe in the power of images and the impact they can have on others, even when you can't perceive it yourself. See other artists as your support network and not as competition. We live in an abundant universe. Develop your own unique style and voice; otherwise, you'll cheat yourself out of the opportunity to expand and grow.

Art is a deep form of communication. I'm really grateful to play a role in that unique human interaction. I love the thought of leaving a legacy of images behind that makes some sort of contribution, even if it's just to bring a smile to people.

www.joannedeaker.co.nz

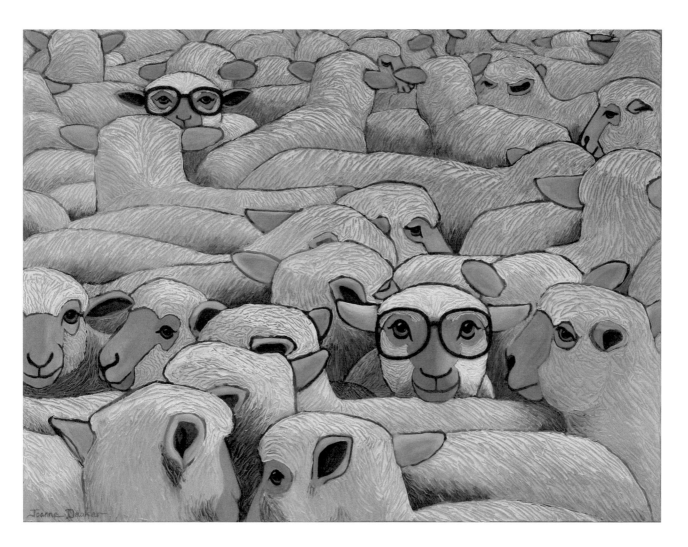

"Trendsetters" by **Joanne Deaker**

Sherri Gamble

Decorative Plaster Artisan & Glass Caster

I knew I was an artist when I opened a can of Venetian plaster from Home Depot after purchasing my house at the age of 29. I was working at Microsoft as a project manager, but as soon as I opened that can and started plastering the walls in my home, I fell in love with being physical and working with my hands. I loved that I could see the visual impact I was making on a wall, as opposed to working in computers, where nothing is tactile.

I knew I had to free my soul from the golden handcuffs of the corporate world. I prayed to get laid off to pursue my passion, and I was two months later! I used Microsoft freelancing opportunities to earn money and pay for a workshop on architectural wall finishes, which helped me build a portfolio and begin bidding on jobs. I earned a degree in interior design, landed my contractor's license, and founded my own plastering company.

It's up to you to create your own mold. My biggest struggle on this journey was feeling frustration that I should be doing something else with my life other than what I was doing at my corporate job. My husband and family cautioned me to stay in the safety of Microsoft. They were stuck in a fear space and couldn't see my vision. I didn't feel they understood who I truly am; they wanted me to fit into a mold of who they thought I should be. But you must find the courage within yourself to move forward toward your dream. You have to resist complacency and be open to the next nugget of truth. The flicker of your passion will ignite into a bonfire you can't ignore.

A new evolution in my work is to help people appreciate the memory of their hands. In my HAND-HELD public art project, I travel to communities and help people make molds of their hands and cast them in plaster. I want to inspire them to work with their hands, to pick up a tool instead of just typing on a keyboard or playing with a video game controller. I desire to infectiously spread texture to their lives through plaster!

Plastering a person's walls often marks a life transition they've just experienced, such as a divorce, a death, or a graduation. With hand casting and my glass casting, it's another way to preserve memory. Sometimes, I receive calls to go to hospices to cast people's hands, which has led to deeply spiritual moments. A son invited me to come to his father's hospital room and cast a mold of his hands. The father had dementia, and it was a way to preserve a family member in a 3-D sculptural way instead of a photograph. As we age, our hands become more gnarled. Casting hands in a mold captures a snapshot of their evolution.

I've gotta go on my journey; I'll be back. Going on my journey means transitioning into the world of creativity, whether it's going to my studio to work on a painting or casting project, or facilitating a community arts project in Pullman, a suburb of Chicago that has a history with the labor movement and architecture.

You develop a different perspective of the world when you're looking at it from the level of curiosity and creativity. People in your life, including your family, may not possess the same values. As an artist, I have to vacillate between the two worlds of everyday routine and the higher realm of creative inspiration. I set strict boundaries around my creative time. My husband has been my greatest encourager, because once he recognized how important it is for me to take creative voyages of my own, our relationship changed for the better.

Texture is my muse, whether I'm working in glass, plaster or paint. I love to see really old spaces, abandoned buildings, a fishing pier - anything that's weathered by nature so it's textured with rust or a patina. Then my filters are off. Don't try to walk with me in the city, because I'll be taking my time! I'm inspired by every textural thing I can find. With my wide filter, I take photos of rusted metal, a big pile of junk, or a beautiful wall to document them. A relationship always exits; there's a common thread throughout each piece. Spreading infectious joy is also inspirational. Watching people unmold their own hands and seeing the impact it makes on them to create a unique memory gives me the biggest rush. It's almost addictive!

I'm a creative whack-a-mole. My newest vision is having an "artmobile" and traveling from town to town to share the craft of plastering and mold making. I'll take my plastering tools to wherever a hungry community is that values curiosity and making things with their hands.

Be who you were born to be, not who someone else expects you to be. Surround yourself with people who support your authenticity, and make it known that that is what you value in life.

The legacy I hope to leave is inspiring people to recognize the value of their hands. Use your hands to create instead of destroy. With all of the different ways we can use our hands, which of those practices are helping you, and which are hurting you? Recognize the power of your hands and create things to love instead of damaging things.

I had an interesting conversation with a Chicago police officer, who said he loved to bang on metal outside of work, just to decompress. I want to inspire others to use their hands to decompress as well, maybe not necessarily to create things all the time, but to use your hands to channel emotions.

I want my hands to be on as many walls as possible. Some of those walls will get torn down at a certain moment in time, but to know that layer after layer, my hand has been on those plastered, textured surfaces, and I've internally told my own story on them gives me pleasure.

www.earthhousestudio.com

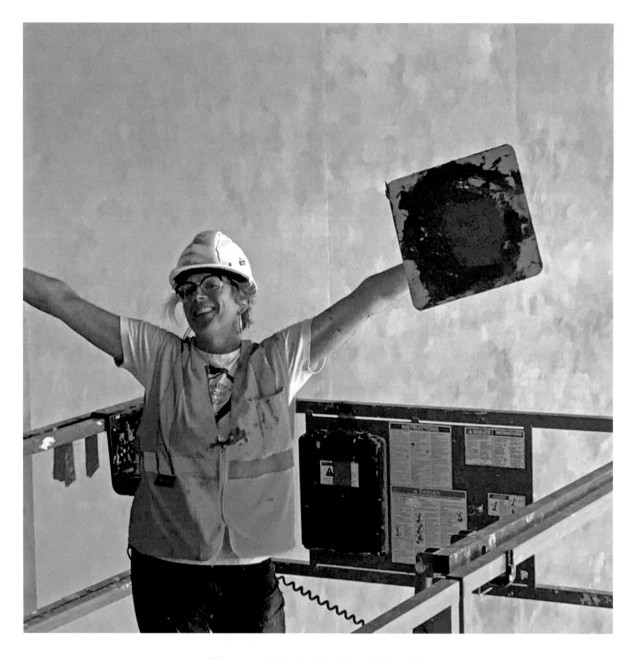

"Skyspace" Project by **Sherri Gamble**
Olympic College CIC Bremerton, WA

Lorie Hoffman
Pop Artist

"I can do that!" I excelled in math and science in high school, and counselors encouraged me to become an engineer. So, I enrolled at Montana State University as a mechanical engineering major. Within two months, I realized I hated it! I loved the math and problem solving, but I hated the environment. I did what many frustrated college freshmen do – got drunk and talked to my dorm's Resident Assistant, who was a photography major. I thought, "I can do that," even though I hadn't experimented with art in the past. My mechanical engineering brain still fuels my art today. I'm fascinated with technical drawing and learning how human and mechanical systems work, as well as how they're made.

I did a project where I drew a hand tool every day for a year. I used my parents' tools I found in their house and garage: my mom's embroidery hoop, my dad's vice grip. Some of the tools have been in my family for generations, and they represent the craft of making. Although I began the project as a means to study the design of each tool, I discovered an incredibly personal love that developed, which I didn't expect. Each tool picks up the essence of the person who has worked with them. For example, my dad's leather punch has a grip made of leather. His hand imprint has imbedded on the leather grip, because he's used it so many times.

The structures of how things work, such as traffic light systems and plumbing systems, are the main influences behind the cityscapes I draw. I think about the structure of a city, such as Seattle, and what goes into making this giant organism function. Growing up in rural Montana, my fascination originates from the wide-eyed-ness I experienced on first moving to the city.

I dissect each part of a building to discern how this organism works. I've used blueprints, archive photos, and even a patent for an electrical power converter to inspire my art. I consider the walk/don't walk sign or manhole cover in front of the building, the set of the windows, the number of stories, where cell phone towers are located. Then I can layer each piece in a precise drawing that results in a clean, beautiful cityscape artifact. The viewer won't see the plumbing or the cell phone tower in the drawing; they'll see a pretty illustration of a building that perhaps has an emotional significance to them. For me, it's a personal journey in which I rebuild a city piece by piece in a way that makes organizational sense to me.

My pen and ink crosshatch drawings can take up to eight hours to complete. I scan the drawings in super high resolution and screen-print them into various sizes. I don't work in the mid-range. My hand tool prints are only six inches, while my cityscapes have reached 10 feet by 20 feet. I tend to work very small or very big.

One of my biggest hurdles is accepting that I'm not a hugely prolific artist. In grad school, where I studied screen-printing, my professors expected me to crank out 10 to 20 original works per month, but I found that level of output was almost unattainable. Now that I work as an arts administrator, I have access to hundreds of artists' work, and I see I'm not alone. I'm realizing that different people simply have different levels of creative juice. I have a seasonal workflow; in the summer I have more creative energy, so I draw, in the winter I become more introspective, so I produce prints. I turn to processes, such as photography, printmaking, and screen-printing, so when I do make an image, I can produce multiple versions of it.

Professionalism is the key. As an arts administrator who sees a spectrum of artistic work, I realize that success has infinitely less to do with inherent talent or creative output as it does with an artist's professionalism. An artist whose work may not be the best, but they are committed to finding the right target audience for their work, will win out every time versus a very talented artist who is not willing to effectively market their work. Professionalism also includes answering emails in a timely manner, following instructions precisely when submitting art applications, and presenting yourself authentically.

Get really comfortable with failure. A professor taught me to expect a 20-to-1 ratio: 20 rejections for every one acceptance of your artwork for grant proposals, juried shows, artist residencies, or other venues to which you submit your work. If you're getting accepted more often than that, you're reaching too low and need to apply toward more aggressive or prestigious outlets. If you're being accepted less than that, you're placing your bar too high. The ratio is handy, because when I do receive a rejection, I think, "Alright, one down, 19 to go. Getting closer to acceptance."

This is how the sausage is made. I sit on many juries as an arts administrator, and I can ensure artists that it's very rare that someone is rejected because their work sucks. Your work may have been rejected, not because it's bad or because they don't like you, but because they needed to balance the show. For example, if 20 silversmiths apply for a show when only a handful of photographers have applied, the jury may reject talented silversmiths to balance the show's art content to appeal to a wider consumer base. Get to know your local gallery owners, art council members, or public art coordinators. Ask them for constructive feedback and build a relationship with them. When the next show pops up, they will have you in their mental hopper.

Art versus paperwork: both are necessary. I hope to impart a deeper understanding and respect for business practices within the art community. You can make incredible artwork in your studio, but if you can't submit the proper paperwork for a show, grant, residency, or your taxes you won't succeed. I'd like to expand my teaching of art business courses and demystify the left-brained elements some artists find daunting.

www.facebook.com/LAHoffmanArt

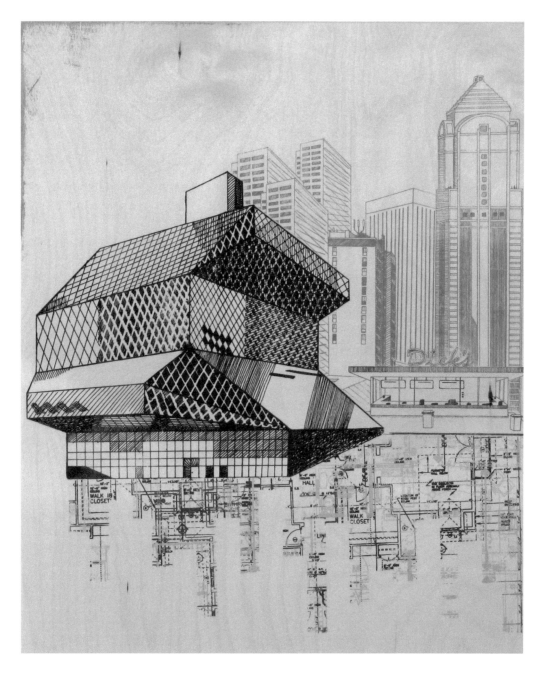

"Cityscape: Transition Part 2" by **Lorie Hoffman**

Kadira Jennings
Oil Painter

I didn't fully own that I'm an artist until the age of 64, even though I began painting when I was 15. I attended a workshop and the facilitator asked participants to divide a page into two sides. On one side, she instructed us to write what we would like to earn in a year, and on the other side, a word or phrase that we would hate for somebody to say about us. My word was inauthentic. The facilitator then said, "Now apply that word to yourself. How are you being that in your life?" When I realized this related to my art, I went into a complete meltdown!

Leaving high school, I was unsure what to do next, so I enrolled in art school and became an artist. I realized during that powerful exercise at the age of 64 that I never felt like I was truly an authentic artist; I felt like a fake. This negative perception affected my whole way of life at a subconscious level, because I never believed that my paintings were worth people buying them. The exercise allowed me to finally claim, "I am an artist" and begin to dismantle the layers of limiting beliefs about my self-worth.

"If your soul is calling you to do something, why aren't you doing it?" A while ago, I saw a photo on Pinterest of some dresses in a wardrobe that seemed to be emerging out of the darkness. I was so drawn to that image, but I was painting landscapes at the time, so I resisted switching to dresses. A friend encouraged me to follow my desire. As I began painting these dresses emerging from the dark wardrobe, I burst into tears. I remembered that I loved ballet as a child, but gave it up at 14 to focus on academics, which I perceived as my parents' wish. The dresses in the wardrobe connected me to the grief I had suppressed when I gave up dancing. I created a series of paintings showing the dresses coming into the light, dancing and floating. They symbolize the emergence of my soul after a period of darkness.

Painting that series of dresses led me to learn about quantum physics through the teachings of Jean Houston. I'm currently working on expressing the connection between the light of spirit, movement and feminine energy through painting a flower series. I begin with dancing in the morning and trying to embody the feelings of love and femininity, which I want to channel into the painting. It's like that dance is extended onto the canvas. The world is crying out for a strong sense of feminine essence, and I want to offer that uplifting spirit through my art.

I sketched my Inner Critic and named him Borus. I encourage my art students to recognize and name their Inner Critic which causes them to be fearful, and shut out their intuition. I ask them to imagine that Borus has a volume dial on his chest, and they have the power to silence him. It is also useful, when doubts creep in, to visualize that Borus is in a rubbish bin and shut the lid on him.

When we can change our story and start telling ourselves a much more empowering and joyful version, the things that we really desire start appearing in our lives. We have the ability to rewrite the self-limiting belief patterns we absorbed during childhood. We can look for the gifts in what seem like negative situations, such as being rejected by an art gallery you had your heart set on. It's very potent.

New Zealand, the country of my birth, is my greatest artistic influence. I possess a deep connection with the landscape, which was given to me by my parents. When I was a child, we would go out roaming the hills every weekend, discover old mud brick cottages, swim in icy streams and snow, and go panning for gold in the creek. I return there every year if I can, to renew this connection to my muse.

If you've got your paintbrush on a canvas, you're an artist. You need to begin believing in that now. You might not be a professional artist; that's a different thing. But if you're creating and striving to become better as an artist, that's part of the artist's journey. Even if you give it up, like I did for a period of about 11 years due to family obligations, your creativity is always with you, and you can always return to art. I'm living proof of that.

Don't go to art school; learn from a professional artist with whom you connect. They can teach you proper technique, such as mixing colors, and objectively critique your work. If you take on art as a career, realize you are an art-preneur. You'll need to spend 70 percent of your time on business aspects, such as marketing your work, promoting it on social media, and attending gallery openings. The remaining 30 percent of the time, create your work. You can't afford to neglect one at the expense of the other.

Do you need another form of income to support your art practice and lifestyle? Yes. I dipped my toe in the water with teaching one or two art students. Now, I run an art school that enrolls up to 40 students, which is my main income. When you're teaching art, you're keeping your eye and hand active, because you're constantly correcting students' work. You might not be working on a canvas itself, but you're still practicing art through instructing others. Don't begin expecting your art to support you.

I believe that a work of art is not complete until somebody views it. Every work of art gives off the artist's own unique energetic vibration or subtext that can be felt by the viewer. I hope to bring joy or a moment of enlightenment to others through their experience of viewing my artwork. If my art can open the door for another to expand their creativity, it becomes a wave that extends around the world.

http://kadirajennings.com

"Dark Beauty" by **Kadira Jennings**

Crystal Lockwood
Sculptor

I met a driftwood sculptor at a dinner party when I was 17. After we finished eating the meal, Sigmund DeTonancour said, "Do you want to see my work?" As he showed us his portfolio, something came over me. I felt an immediate connection. I didn't know he was looking for an apprentice, but I thought, "I want to do this."

Sigmund taught me the craft of carving driftwood. He encouraged me to enter two of my pieces in an art show when I was 18. I sold both pieces! Those sales were a validation that people responded to my work, and perhaps I could make a living as an artist. Then, I entered an art competition at a local gallery and won first prize. The gallery gave me a solo show, and I sold all of my pieces during the show.

Four years later, my father said I needed to attend college. I told him going to college wouldn't change my decision of being a sculptor. In that moment, I realized that I was verifying to myself that I was going to be an artist. No other option existed. I majored in art history at the University of California, Santa Barbara, which greatly influenced my work. I saw a link between my work and ancient Greek and Roman sculptures, as well as Michelangelo and Rodin. I felt this deep connection to sculptors of the past, and I could see a line from the ancient work coming straight to me.

My driftwood sculptures are archetypal. They have a quality of looking old or ancient. Yet they're still modern, because I retain the natural and rough organic characteristics of the wood in the figures. Sometimes the sculptures look like they were dug up out of the ocean. I strive for that worn look. My pieces are mainly female because the driftwood is very feminine. It's curvy and undulating with a flowing goddess energy to it.

My parents died when I was 27. I was so lost and overwhelmed that I actually became suicidal. I didn't sculpt for about a year. My grief counselor said, "You know, maybe, you need to create. Maybe, you need to get into your work." I resisted at first, but that was a crucial turning point.

Now, when I'm feeling down about my art or sales aren't happening, I get in my studio, listen to opera on my iPod, and just work. I learned that if creating art can bring me out of that enormously consuming grief, it will bring me out of anything. I also call on my family of artist friends who support each other. And, I sometimes look at photographs of my past work to see the bigger picture of my artistic journey. I remember to be grateful for what I have, which is powerful.

I think my main muse is the driftwood itself. I try to have a dialog with each piece of wood and form an

idea of what I want to sculpt. I push, and the wood pushes back. The wood always wins! If I don't go with the organic shape and natural energy of the wood, it doesn't work. It's almost as if the piece has its own voice and its own soul.

Many of my pieces are from the root systems of trees I find washed up on the California and Oregon beaches after a storm. The roots are naturally curvy and curly. The driftwood is also shaped from being tossed around in the ocean; that's how it gets its smoothness. It's somewhat sculpted by the waves before I get to it. My hope is for people to see the driftwood's journey in my work, from tree standing tall in the forest, to being violently tossed in the sea after a storm, to emerging as a graceful figure.

I bring the driftwood pieces to my studio and line them up. Many times, ideas come to me when I see a shape out of the corner of my eye. It almost takes me by surprise. The inspiration often comes from just a part of the wood that looks like hair coming down, a piece of drapery, or I see the curve of a waist. A figure emerges from that one part. Sometimes, the wood has a big hole, rock or a bunch of rot inside, so I have to change the design and work around it. It's a subtractive process. I say, "Oh, okay. I see you now. I hear you."

You just need to show up. You can't live in a bubble. You have to expose yourself. Don't limit yourself by saying you don't have a studio in which to create. I've carved under a tent. I've carved in my bedroom. I've carved in my living room. I carved on a hill in Santa Barbara. I mean I've carved on places you wouldn't believe, but I just took my tools everywhere. A space to create will come. It's important to create and experience that bliss. When you're in that bliss, the other things start to naturally fall into place. You have a gift, and it's meant to be for you to use that gift. Hold faith that the universe will support you.

I've learned balancing personal relationships with creating my work can be challenging. Sometimes relationships suffer. I'm learning to adjust my schedule and seek quality time with people who fuel my soul, and I theirs.

The legacy I hope to leave is my sculptures themselves. They're going to be around long after I'm gone and after the people who buy them are gone. They'll become part of the history line of art. Since I learned from Sigmund as an apprentice, I've taught a few apprentices as well. I want to expand mentoring and teaching to pass along my knowledge as a legacy. I think about how different my life would have been if I hadn't met Sigmund and I hadn't learned my craft. It blows my mind. The gift he gave me is just so huge and incredible. I want to pay that forward to artists coming behind me.

www.crystallockwood.com

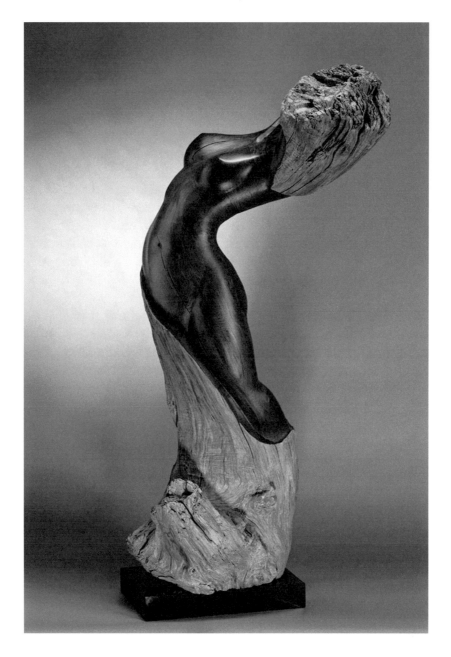

"Pacifica" by **Crystal Lockwood**
photographed by **Jay Daniel / Black Cat Studio**

Ta Thimkaeo
Oil Painter

It would have been easier to walk on the moon than become an artist. I was different from the people in my village in Thailand. As a young child, I wanted to be an artist, even though I didn't really know what an artist was. I just wanted to escape. I knew there was another world out there, but life seemed stacked against me.

I left school at age 12 to work in the snake-infested rice fields. At 13, I worked long hours in a sweat factory in Bangkok sewing shirts. At 14, I drove a pickup truck selling vegetables, although my feet could barely reach the pedals. One Sunday, I went for a walk and came across an art studio with an old man painting with oil paints. He invited me in and showed me what he was creating. I knew I wanted to be like that old man and paint. I loved the chaos in his studio, the smell of the oils and varnish. I was hooked. I didn't know how I was going to do it, but I knew one day I was going to be an artist.

Eventually, I married and owned a thriving car lot. However, I left everything behind with only the equivalent of $83 to escape a controlling 16-year marriage to my now deceased ex-husband. A couple months later, I was scrubbing toilets and ironing laundry in a hotel in Koh Samui when I met my present partner, Gary from the UK. My life completely changed, although he didn't speak Thai and I didn't speak English. It was raining, and we were stuck indoors. I was bored, and drew a caricature of Gary on the back of an old receipt.

Most girls receive chocolates or perfume; I got art supplies. On a trip to the UK, Gary brought me back pencils, pastels, charcoals, brushes and oil paints. I was in heaven! I briefly worked at an art gallery and traded beer and cigarettes with local artists for their knowledge of painting techniques and mixing colors. I opened my own art studio and began selling my work to resorts and private homes. However, I was still struggling with my limiting belief that because I hadn't been to art school, I couldn't be a real artist.

I felt like a rat. Many times I wanted to quit. Sales were low, and the paintings were piling up. But, Gary wouldn't let me stop. I honed my painting identity and focused on my "Memories of Thailand" and "Nude Ladies" series. My style became more colorful and less broody as my fears began to subside. In my "Memories of Thailand" series, I use my imagination and childhood memories for inspiration: men on early-morning fishing trips; the colors, smells, noise and local people of the markets I remember as a kid.

My "Nude Ladies" have always been with me since my earliest drawings. When I owned the studio on Koh Samui, many Thais, including kids, furtively peeped into my shop, because Thais aren't used to seeing nudes. Some people say my Ladies are grotesque, fat and ugly, but I consider them beautiful. They may not fit

the Thai vision of long legs, slim build, and white skin, but I don't want my Ladies put in a uniform box to please a small portion of society.

One morning, I awoke to discover I'd sold a painting to a buyer in London via Saatchi Art! Then an agent, who lived on Koh Samui, invited me to exhibit my work for one evening. I put on a little black dress and red lipstick and stood on stage to give a speech. Gary had tears running down his cheeks; he was so proud of me. I finally realized in that moment, I am an artist.

You have the power to overcome any limitation! Where I live in Thailand, it's very rural with no shops selling art materials. I found a store about 100 kilometers away. I call the owner to order what I want and pick it up from the local bus stop. A shop in Bangkok can mail me any supplies I can't find locally.

I get annoyed when experts give me advice on marketing and say I should become involved in art galleries, fairs, exhibitions, or artist groups. If I had access to them in Thailand, believe me, I would. Thais love photos of our kings, monks, Buddhas and history scenes, but we don't have fine art galleries, especially that sell nude paintings like mine. Without online galleries, selling my art would be impossible.

The online art market is growing rapidly, and once you learn the ropes, it's a golden opportunity to showcase your work. My online store is open around the world seven days a week, 365 days a year.

I've sold my paintings in 17 countries, including several cities in Europe, Peru, and the US. I get excited when I sell a painting, and look on a map to find out where its new home is. One of my works is hanging on a buyer's wall in Windsor, England, near where the Queen lives! Not bad for someone who went from cleaning toilets for a living to grabbing a golden opportunity with both hands, all from a cheeky sketch on a receipt.

Learn from your mistakes. I used to post photos of my work online, without a title or artist statement, not use social media to promote it, and wonder why it never sold. Art is work, and you have to work hard at it. You can paint the most beautiful paintings, but if no one sees them, you're not going to sell.

Thais have a belief that our life is mapped out for us and what will be will be; I hope my future is bright. I hope people will say, "Ta had a difficult first half of her life, but her second half was pure magic. She didn't live in London, Paris, Monaco, or Peru, but she sent her work there and now she's looking down from the moon. Not bad for a girl from the rice fields of Thailand."

www.artgalleryta.com/home.php

"The Egg Lady" by **Ta Thimkaeo**

Tracy Verdugo
Mixed Media Artist

Growing up I had no context to even begin to think of myself as an artist. In our family culture, art had no place. Yet, my younger brother excelled at drawing. I was fascinated, longing, but my attempts to emulate him ended in self-criticism. I believed that you were either born an artist or you weren't; I believed I wasn't.

I attended my first art class at the age of 33 when my youngest child began preschool. It was as if a veil had been lifted! I suddenly knew that being an artist was no magic gift doled out only to a lucky few. It is a birthright available to all who seek it.

Today I make art with paint, canvas, wood, torn pages, pastels, words, and music. I continually explore and throw myself wholeheartedly into abstract expressionistic pieces, investigating narrative, and merging abstraction and realism.

I believe that life is infinitely convoluted and effortlessly simple, so I seek to add that contrast into my work. I'm drawn to vibrant color and softer hues, energetic areas with calm bits allowing the eye to rest, bold marks balanced with delicate lines.

My greatest resistance has always involved giving myself permission to shine. Being adopted was a life-shaking event and yet it also helped me to understand my deep-seated need to belong and feel connected. I'm learning to recognize my own self-worth as I'm constantly walking the line between standing out as an international artist and wanting to shrink into anonymity.

Expressing my talents through paint, song and written word sometimes feels like I'm shining too brightly. I doubt myself. However, I know that playing small does not serve the world.

It's only by pushing through the discomfort and doing the work that I can overcome these limiting beliefs. I strive to experiment with new subjects, artistic styles and techniques that light me up. Some of the work might be shitty, but when stretching outside my comfort zone, I remember that even masters must be beginners when they start a new task. A success inevitably emerges, and I'm able to say, "I know how to do it. I have the tools. I'll figure it out."

The more I extend myself with my work, the more validation I receive, especially when I see how my teaching inspires others in their own creative process. This allows me to turn down the volume on my longstanding fear and create work that shines.

My husband has been my greatest supporter, even though sometimes it's been tough love. He played music and I sang when our girls were small, and I was paralyzed by performance anxiety. It was hard for him to understand but he was always there, coaching me through. Thankfully, I don't have the same kind of anxiety around teaching art or painting! As I have grown as an artist and a teacher, my husband has been my right hand man, roadie, driver, advisor, packing guy, hand holder, and shoulder on which to cry. As our girls have grown into extraordinary young women, I feel a ton of support from them also. I'll never forget tearing up the first time our then 19-year-old Santana told me she was so proud of me for all that I had achieved.

I'm a curious soul and love the big questions. Life itself, the Universe, is my muse. I have trouble focusing on conversations in busy rooms because the chatty snippets of others call me with potential stories, painting words, and images. I look for beauty and hope in humanity. I'm a better contributor when I'm centered on what brings me joy.

Nature helps me to focus and reel in the busyness in my head. We live in a small village by the sea in Australia, which is surrounded by bushland, creeks and a magnificent bay. I love to walk on the beach and in the bush, to breathe in the quintessential Australian landscape of scribbly gums and bottlebrush trees, parrots of every color flitting around from flower to flower, and the sparkling turquoise waters. My Sacred Waters series has been completely inspired by the colors of Jervis Bay and surrounding bushland. These abstract paintings incorporate many of the curious hieroglyphic marks I find in nature during my walks. I also paint directly on the canvas using interesting "nature tools" that I have collected from the local environment.

My creative process is sometimes messy, haphazard. I'm easily distracted and small rituals help me settle into a painting. Lighting some incense or sage, putting on my favorite music, even tidying a little in my studio can help me to feel grounded and ready. When I'm in flow, which happens mostly when I allow myself several uninterrupted studio days in a row, time is irrelevant and magic happens. I feel connected to something greater than myself, as if there is another force at work and I'm collaborating with it to give birth to my paintings.

The best advice I can give is to do the work. We live in a time when we want immediate perfection and success without the struggle. I'm not a believer that struggle is essential to growth, but experiencing conflict can be a gift and have the purpose of adding value to an artist's personal wholeness and work. So, don't be in a hurry. Put in the hours. Remember to be you, even if that means that you need to find out who YOU are along the way. It will be worth it. I promise.

I'd like to leave behind the legacy of a life fully embraced. I hope to inspire people to live a life less ordinary, to question, and be curious. I'd like it to be said that I was not afraid to share my vulnerabilities, and that in doing so I helped others to embrace their own. I'd like to leave a legacy of hope, kindness, and a sense that we are all intrinsically connected. As Ram Dass says, "We are all just walking each other home."

tracyverdugo.com

"We Dwell in Possibility" by **Tracy Verdugo**

Louise Victor
Oil Painter

In first grade, I hated recess, so one day my teacher let me stay in with her. She drew a simple portrait of me. I was stunned. Looking back at me from this piece of paper was an image of someone who looked a lot like me, braids and all. In high school, I decided not to enroll in art classes, because the instruction focused on decorating billboards and posters, which I didn't see as art. It wasn't until college that I took drawing classes, and I knew that was it. I was an artist.

My dad was a pilot with American Airlines and a World War II aviation pioneer, who established training programs for British Royal Air Force cadets. He taught me how to fly during a time when no female pilots existed in commercial aviation. Several years later, American Airlines hired me as their ninth woman pilot. My schedule was such that I could fly two or three days and then have three or four days off, so I could paint, draw, and visit museums and art galleries in the locations to which I flew. A synergy between the two occupations melded. My father encouraged me to have the best of both worlds.

I don't make paintings of airplanes or what I see from the cockpit; my work is all about energy and movement. I paint the feeling of being weightless, of defying gravity. What I bring from flying is the sense of the tension and release of overcoming gravity. It's painting the "feeling of the air." Flying a Boeing 757 is like driving a sports car, quick and speedy, turning corners really fast. Flying a Boeing 767 is like driving a luxury car, smooth and elegant. When you're flying a small aircraft, you have the ability to make loops and turn upside down, darting this way and scooting that way. That's the feeling I create in my art. When I'm in my studio, those graceful, beautiful flying lines come out in the lines I make on canvas.

Your mind is a wing. When you're learning to fly, you get an instrument rating, which means that you can fly an airplane in the clouds without any visual reference to the ground or sky. Your instruments give you the information you need to maintain a healthy relationship to what exists within the whiteness - mountains, buildings, the ground, whether you're descending or ascending. It becomes like a sixth sense.

The same thing happens with art. If you want to paint a chair or a figure, you must be aware of how a contour turns, or how a shadow falls. You must learn to really see. In the same way that a pilot relies on instruments when flying, an artist must rely on a learned practice of looking. When you're painting, you rely on the familiarity of knowing where you're going with your tools without really seeing in the typical way. Your artistic knowledge gives you that sixth sense.

My biggest struggle is finding an audience that "gets" what I'm doing. I feel that more and more, I'm finding the language to better explain my art to people. It's a process similar to piloting a plane. When you fly, you confront fear, but knowledge and practice help you overcome it. You know the worst thing you can do is panic. Take apart the whole and look at it piece by piece. Then you can see how the parts go together, and you'll have an understanding of it. It's the same thing with art. Once you understand the structure and the language of art, there's no fear and you can create and communicate your point of view freely.

Sometimes you're graced with the sense of being fully immersed in the painting. Milton Resnick called it falling. You have to stop yourself from falling out of this state, remain suspended, flying. You've been working for an hour and it feels like minutes. It's in those moments that the work seems to spring forth fully formed. Both flying and painting sharpen the senses. You exist in the moment. I crave the ability to have those moments in my studio, just as I crave the ability to travel through what seems like empty space that exists somewhere in the air.

Learn your craft and be curious about your craft, always. It is very important to read, look and attempt to understand a painting, how that painting fits into the continuum of artistic practice. Curiosity makes you delve into what you're doing and why you're doing it. It's what got me started on this path. I'd do something intuitively, I put a mark somewhere on the canvas and it would work, it would work every time, and I started thinking, why? Why does that always work? That got me started looking for answers, and in the process I discovered that there are guidelines. That's the informed intuition. When you know why and how something works you can use that muscle memory effectively. You can build relationships based on that information. You have to have the confidence to possibly ruin a painting in order to push it forward. If you're curious about your craft and you learn about it extensively, you're going to be miles ahead. You're going to make better art. It's just that simple.

What I recently discovered is I really love to teach. The legacy I hope to leave is that my teaching leads to a greater understanding of the creative process. With my perspective of seeing the world from a cockpit, I would like to leave behind my sense of being in the world. I can teach someone how to connect with their unique being in the world, how to explore their own unique connection. I can give people the tools and encouragement to find ways to express that for themselves. You have to first find your inner voice and block out all the peripheral noise. Learn to listen. Trust yourself. It will not lead you astray. It will provide you with a firm grounded footing as you reach for the stars.

www.louisevictor.com

"Time After Sometime" by **Louise Victor**

Judi Wild

Environmental Artist

My creative mother recognized my gift before I did. When I was 4 years old, I was drawing on the walls of our house and spending hours sculpting with Plasticine. My mother used to tell the story of how amazed she was when I showed her a perfect replica of a camel. My family had no television at the time living in rural Alberta, Canada, so I'd never seen a camel, yet somehow I knew how to sculpt it.

That year, we moved to England, and my new school introduced me to watercolors, which I still use today. My first experience of knowing I'm an artist was when I was 11 years old and my watercolor painting of three students playing netball was displayed in the school's art exhibition. I remember that painting like it was yesterday, even though that was 60 years ago. I loved the feeling of sharing my art and receiving compliments, which fueled and validated my inner passion.

Today, I absorb my creative inspiration from Canada's natural world. It's my religion, my church, my spirituality. My love of the natural world is in my blood. My Great Grandma was an herbalist, and people would come from far away villages in England for her advice and fresh herbs. I'm drawn to the traditions and culture of the Haida Peoples and the Haida Gwaii islands on which they lived surrounded by the Pacific Ocean. I share a mutual respect and concern for the environment with this ancient coastal tribe. I use salmon as a common thread linking my "Spirits Series" paintings, because salmon was the most important food for the Northwest Coast peoples. I also incorporate totem poles that display the clan crest and social status of a family extensively in my paintings, even working from small black and white photographs taken as far back as 1901.

Through the years, I've developed a unique watercolor technique. Each painting takes approximately 300 hours to complete, and I see it as a form of meditation and therapy. I use a limited palette and a labor-intensive dry-brush technique. I begin by applying several layers of transparent color over a completed pencil drawing, followed by hours of intricate detailed work, so that very gradually the color appears. This process allows me to complete only one major work per year. My images have extreme depth to them, as though striving for a 3-D sculpture look. Sometimes it seems like an eternity to transpose a "flash of inspiration" from a blank illustration board into a finished painting, because of my fascination with detail. My greatest challenge is to delve deeper and discover the delicate designs, shapes and textures nature provides.

I don't think I became an artist; I was born an artist. I experienced little resistance in allowing my artistic side to shine. My greatest fear was not having enough money on which to live, because I left home at 16 to pursue a creative lifestyle. I worked full-time in Alberta while taking night classes to qualify for positions that

related to visual arts such as civil drafting and graphic design. But these careers never satisfied my creative urges. I began burning the midnight oil in my art studio, which resulted in high profile gallery shows and sales to faithful clients. The corporation for which I worked even asked me to design the city's phonebook cover and printed limited edition lithographs of the original painting, which gave me international exposure.

However, I became burnt-out. I would come home from my day job, have a nap and at 11 p.m. make a pot of strong coffee and paint until 3 a.m. In 1991, I had just finished a portrait of Mother Teresa and upon signing the painting, I put down my brush and made the decision to give up my corporate job and move to Vancouver Island to paint full time. Following this dream meant letting go of my large client base of coworkers and starting over as an unknown in an area full of artists. I was lonely and sometimes hungry and scared, but my renown rebounded.

My biggest resistance today is having the discipline to shut myself away and do my work. I've learned to set boundaries by letting people know that I'm in painting retreat each winter. During summer, I "switch personalities" and come out of hiding. A new struggle is wanting to reinvent myself. My inner sculptor, who created the camel as a child, is longing to be heard. If you're known for a certain type of art, your clients may not be comfortable with change, and I'm fearful to step out of that comfort zone. However, I recall the words of support from my number-one fan, my mother, who said, "Those are able who think they are able." Then I experience a surge of joy thinking about the new adventure unfolding.

My advice to upcoming creatives is to know you are an artist. This gift is present at birth, but may be hidden until later in life. Its creative energy may seep out in various ways or the suppression of this talent may explode. If you need financial support, choose a job where your creativity can be nourished. If you can't produce a large quantity of paintings, sell prints through a distributor of your popular images to produce exposure and income.

Make your clients feel special. When I finish a new work, I mail hand-inscribed announcements on homemade paper, and offer each customer a special artist proof if they order before the run is printed. This assures I have money for printing and gives them something special directly from the artist. I guarantee clients the same signed number, which they have for prior images in a series. Collectors enjoy acquiring an entire series and to have matching numbers makes the set more valuable.

I hope the legacy of my art portrays my connection to the environment. I want people to appreciate the vulnerability of nature and wildlife. Perhaps through my art, future generations will remember the wisdom of our ancient First Nations Peoples and their respect of the environment and life.

www.judiwildartist.com

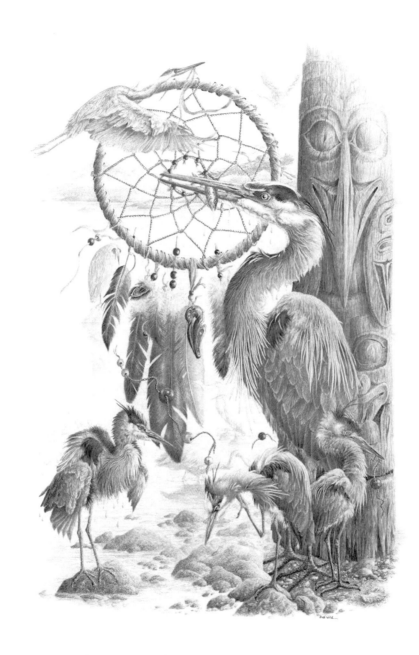

"Spirits of the Great Blue Heron" by **Judi Wild**
photographed by **Coast Imaging Arts**

Judy Winter
Nature Artist

I picked up painting as an adult after leaving it behind as a child, because art was a therapeutic release from the pain and suffering I witnessed while working as a nurse. I listened to Josh Groban's music and my paintbrush just moved, like I was an extension of the paintbrush. I thought, "There's magic in doing this!"

"Okay, I'm not a nurse anymore. I'm an artist." A friend asked me to paint her 30-foot long, 10-foot high retaining wall with a line of sunflowers during my free time from nursing. Then I painted my own retaining wall and another friend's garage wall. I began painting smaller pieces and selling them to friends and family. This led to submitting my work to open exhibition calls over several years, and I landed a solo gallery exhibition in November 2015.

My biggest fear was being selfish. My family needed my nursing income to send our kids to university; that was the purpose. But, even though I was given the gift of healing, I never considered myself a nurse. I wondered, "Hasn't my whole life directed me to become a nurse? Isn't this what I'm here for? If I leave, am I just going to 'play' as an artist?" It was my daughter having a baby that actually brought me through my fear of letting go of nursing because her baby was two months premature. I helped take care of my granddaughter when my daughter returned to work. I watched her play with her Crayons and coloring books and the joy art brought her. I began to see that I'd given my adult life to helping others; now it was my turn. In essence, my granddaughter gave me permission to become the artist I was born to be.

I come from that. If they can do it, I can too. My grandfather was a watercolor artist. He'd sit on a bench at Clover Point in Victoria, BC and look out across the Pacific with his watercolor kit and paint. I watched him and thought he was so wise and gentle and so at peace when he was painting. My dad was also a painter, extremely detailed and focused. It thrilled me.

I paint the feeling I get from focusing on elements of nature. I always think the world doesn't have enough bright in it; it doesn't have enough color. So, I'm drawn to using vibrant colors in my work. I think, "This is what I feel when I look at this lake. I feel there's deep peace. I feel the sparkle on the water. It's so full of love." That's what I want to share with my art. Painting is the perfect way to tell a story. Everything in the world is giving you a message, like two birds sitting together on a wire. You don't need the words anymore. You can just paint it. I want to make people feel joy through my art.

I'm really the strongest artist when I'm by myself. Solitude gets me into that space because you can

control your own environment, but you can't if you have other entities inside your creative space. They take you away from your brush.

However, I've received invaluable encouragement from close friends who have pushed me to new artistic levels. A long-time co-worker, Agnes, is probably the main reason that I believed in myself as an artist because she brought me along on her spiritual path, teaching me the concepts of A Course in Miracles and Law of Attraction. She taught me to be aware that it's not just me trying to create something; it's me being given something to create from the Divine. For example, on a walk through the woods, I saw the most vibrant green moss that seemed too brilliant to be real. I thought, "Wow, I've been given this. I need to make that green!" I had a dream about this moss on shadowy larch trees at night, and painted it the next day on canvas.

My advice to upcoming creatives is to believe that the reason you're wanting to be an artist is because you're meant to do this. It's your desire. The world needs artists. Art gives you a peaceful, beautiful, mind-opening experience.

Know that you'll have slumps and moments where you'll achieve. It's never ending. It's the journey. There's no point in focusing too much on, "Oh, I wish I could sell this, or why can't I make a living as an artist?" You have to take that leap of faith. Say to yourself, "I'm on the course and I'm doing what I'm meant to do. Come what may, I'll keep being brave." Surrendering to your path is necessary, even if you can't see the outcome. You can't force the outcome that you think you want. Just keep moving toward your joy.

I truly believe that what you choose to do on an individual level is translated into a national and international level. Creating your art contributes to the world. We don't want to get lost in the base things on earth. What a blessing it is just to be alive and to share the joy of art and not get caught up in the world's battles.

Sometimes, what you want to say with your art, you can't say until you've gone through certain experiences in your life. For example, the love I feel for my granddaughter is overwhelming sometimes. If I'm painting and I'm thinking about her, it's almost automatic that these pinks and whites show up on my canvas. Life brings something to you that you can share.

The legacy I hope to leave behind, especially for my children and grandchildren, is that I wasn't afraid. If I wanted to do something, I did it. I was willing to share my art with the world. I believe the earth is a beautiful place. I believe we are nature. I want people to feel that if the human race is going to carry on, we have to love nature. So, I hope for people to see the importance of that through my artwork.

www.judywinterpaints.weebly.com

"*Fisher Peak Dawn*" by **Judy Winter**
photographed by **MaryAnn Bidder**

Meghan Yates

Acrylic Artist & Art Monk

My artistic awakening blossomed during my sophomore year of high school. I became conscious of the fact that when I got into trouble or when my life was stressful or chaotic, I gravitated to my sketchbook to process what was happening through creativity and engaging my imagination. I also realized that year that I wanted to go to art school. Other students in my community were becoming doctors, lawyers and "serious things." I recognized art was serious for me. Art was a dance that I couldn't help but participate in.

This is my path; there is no other way for me. Both of my parents were visual artists and musicians; however, they didn't think I had the talent to go to art school. As a teenager, I moved in with my late father, who was also a fisherman in Maine. It was a harsh period in my life. My dad was an abusive man, and we weren't close. I sketched a solemn drawing of a girl with a slightly tilted head and perplexed look on her face. Her hip was proportionally structured, but crooked. I've always had issues with my right hip caused from a moment of abuse from my dad. He saw the drawing, and although he didn't understand the meaning, he registered the emotional potency of it. He tearfully said, "I know why you're going to art school."

My challenge became allowing my own voice to emerge. During art school, I wanted to express the private and public aspects of the feminine, the messiness of my interior stories, family history, and exploring the spiritual realms. But, my professors didn't fully receive this vision, so I created these personal artworks behind the scenes. A couple of years ago, I discovered a "30 faces in 30 days" painting challenge on Instagram, which ignited my daily practice. I decided to continue the daily process by creating one painting a day on 6" by 8" archival paper. I'm currently in my second year of this practice.

Through daily painting, I'm discovering new things about myself as a woman and artist. I'm exploring different techniques and subject matter and connecting with my inner life through this practice, which was an unexpected revelation. The daily practice is helping me find my true voice. I'm learning to let fear reside in the back seat, but not drive the car. Fear helps me recognize when I'm coming to a new edge of my growth, and my spiritual muse sets breadcrumbs on the path leading me to that edge.

Spirit is my muse. It's so close it's like breath. My commitment to spirit is tied to wanting to be in relationship with my eternal all-knowing self. It allows me to have access to information that I can't see unless I'm engaged in an imaginative, creative process. I align with spirit through my daily painting practice. I tend to create projects for myself that are slightly beyond my scope or skill set. I love learning and expanding myself. I'm not harsh on

myself. It's not about achieving something. Rather, it's about relaxing into process and practice, which opens space for me to hear the voice of Spirit.

The muse is leading this dance, and I don't always know the steps. I'll set an intention to paint something, but my spiritual muse will take it in a totally different direction. Sometimes, I'll spend an hour struggling with a painting. Maybe I'm not feeling well, or the painting isn't saying anything. I've found new processes at times like this, such as dumping black paint over the whole thing and scraping the excess paint away with a palette knife. When I get out of my own way and let the process guide me, I'm often left with something much stronger. Spirit's agenda is revealed through the texture of the black seeping into the crevices, showing the mess, showing the effort and release when I'm finally able to relinquish creative control.

My practice is one of an art monk. After going to art school, I attended seminary. My art is absolutely supported by my spiritual practice. Trusting the process of unfolding, encountering, listening and responding is the concept that repeatedly bubbles up in my spiritual and creative lives. Perhaps the small act of painting every day encourages me to smile at somebody because I feel good. Or maybe the creative process workshops I offer the community improve conditions in a subtle way that create a ripple effect that leads to bigger changes.

If you're afraid of a blank canvas, are you afraid of creating your life? This is the purpose behind my contemplative art classes. If you can face a blank canvas and recognize where you're limited or afraid, you'll be more equipped for dealing with other areas where you're resisting, such as family expectations, politics, or your relationship to money. My classes teach people that if you can paint, perhaps you can work through other obstacles too.

I want kindness to be my legacy. The ancient teachings of the Mi'kmaq, my mother's people, include scrolls. The first scroll regards kindness. The first section of the scroll of kindness says three things: "What do you want? What are you willing to do to get it? Share what you know." I want a juicy, rolling life of interaction through my community art projects. I love the joy it brings people to invite them into an intimate, or even a strange moment, and encourage them to experience a flash of closeness with themselves and others. To achieve that, I'm willing to take risks and be vulnerable. I'm willing to walk as myself, not shrink, and to share what I've learned. Kindness is radical and subversive, just as being a creative, life-generating, problem-solving female is radical. Creating art is more than putting paint on canvas. It's offering what's in your mind and your holistic view. I want to share that freedom with others.

www.meghan-yates.com

"Crow And The Pearl" by **Meghan Yates**
photographed by **Carly James**

Gwendolyn Zierdt

Handweaver & Internet Geek

My dad explained that electricity is like water. His workshop was in our basement, and the kids in the family had our own tools and workshop bench. Dad brought home a project for us to ponder: figure out the engine of a small remote-control powerboat and get it to work. I was five years old and couldn't sleep, so I snuck downstairs to try it. All of a sudden, the boat engine jumped to life and began buzzing loudly. I thought I was in big trouble; I was supposed to be in bed. Instead, my dad was impressed. He said the guys in his flight crew hadn't been able to solve the puzzle. I seemed to possess an innate spatial reasoning that no one had taught me.

It's just a piece of fabric, but holy crap! I create hand-woven textiles that deal with systems and pattern that relate to computer code and current technology. My textiles are strongly influenced by historical textiles, particularly African strip woven cloth. Instead of using historical and cultural references of other nations, I've incorporated my own cultural references, such as functioning QR codes. For my "Public and Private" piece that exhibited in "Bits and Bytes," an Art and Technology show at the Bellevue Arts Museum, I used a draw loom to hand-weave 35 unique QR codes into a strip woven cloth. I created the physical pattern for each QR code and wove the pattern so the codes can be "read" by a smartphone. The weaving was challenging, because I had to maintain a consistent beat for each QR code so the pattern could scan correctly. Fabric is soft and stretchy, and isn't well suited for the sharp contrast in light and dark needed for a readable QR code.

Each QR code contains a unique URL, which redirects to a website that either advocates for public access to or supports increased privacy of online information. The links go to self-documentation that explains each of the QR codes, government and legislative sites, federal laws relating to privacy, and my artist website. I use a marketing service to manage the links and ensure they always work.

The concept is to examine the idea of "privacy," including when the government wants to access an individual's private data and the free sharing of information, which the government doesn't always desire to participate in. Many individuals don't want to share information, yet they have no control of their personal data because businesses collect information and sell the data to anyone who will pay. So, what does it mean to perform a simple Google search and find information about yourself that you believe should be private?

You don't have to possess a specific technical skill to give yourself permission to do something that's interesting to you. My dad modeled this philosophy by crafting things from scratch: tools, furniture, the trigger mechanism for a muzzle-loading gun. I learned to ask, "What didn't work, and what could work instead?" and to consult others who might offer a new perspective. I became fascinated by looms and weaving after visiting

an 18th century recreated village in Cooperstown, New York, where actors re-enacted colonial times in the U.S. They demonstrated the process of growing flax, how to process the raw material, and then spin and weave the yarn into cloth. I asked for a loom for Christmas, but received a letter from Santa instead that said he wasn't going to give me one. I was crushed. Later, my mom obtained permission for me to take an adult education weaving class when I was 13. My father was against me taking art or participating in sports in school. He preferred that I study math and science in preparation to take engineering in college. Many years later, my dad realized dyeing yarn is all about chemistry, and weaving has a technical and mathematical history. In my mid-40s, my father drove to Canada and purchased a draw loom; "Santa" finally granted my wish.

My artistic and mechanical brains merged. As an adult, the opportunity arose to return to college and earn a second degree. Since my father forbade me to study art as a child, I decided to earn a BFA and an MFA from the Art Institute of Chicago. I also worked for a genealogy software company to engage the technical challenges I had enjoyed while working for Microsoft prior to moving to Chicago. During a one-on-one critique of my artwork, my faculty advisor observed that each of my pieces, whether woven, hand-stitched, painted or marks on paper, connected by some type of system or pattern. I had an epiphany that my love of weaving linked to my success with computer technology. Cloth and computers share similar structures, such as being binary, numerically sequenced, and created through the repetition of small, incremental actions.

It's okay to not know all the answers, to be unsure of yourself, to feel depressed. Part of my legacy is to build community with others. I choose to be vulnerable by sharing my story of growing up in an isolated rural area because my dad wanted to control who my friends were, of stubbornly choosing to study art as an adult because it was forbidden during my childhood, of getting divorced while living in France and having to decide where to move next on my own. I strive to show compassion for others who are struggling; I value the connection that emerges. You can move through difficulties by making choices to help you move out of the muck. You don't need to understand each step; just know a next step toward the life you desire is possible.

Persevere in doing whatever your art is, whether you're a performance artist, visual artist, writer or poet. Just continue creating. You don't have to be successful in the moment, but you must hone your craft. Many artists have worked for years, and then suddenly somebody recognizes their body of work for what it is. It's the commitment of putting time and energy into your work that finally tips the scales in your favor.

http://gwenzierdt.org

"The Unabomber Manifesto" by **Gwendolyn Zierdt**
photographed by **James Prinz**

Vicki Todd

Memoir Artist

My creative DNA sprouted in my Grandmother's china shop in her home attic in Happy, Texas. She sold china and bisque and taught oil painting lessons to ladies in the community. She allowed me to sit in during the china painting sessions and create my own plates. I have fond memories of that little china shop: my grandfather prying open the slatted wooden crates of imported china and feathery shreds of newspaper cushioning spilling onto the floor, the smell of turpentine in tiny pimento jars used to clean brushes.

My mom tells the story of a 6-year-old me answering, "An artist," when southwestern painter, Kenneth Wyatt, the judge of the Little Miss Happy beauty contest, asked what I wanted to be when I grew up. I don't recall the memory myself, but that small Vicki knew why she existed.

My biggest struggle has been to acknowledge what 6-year-old Vicki knew from the beginning: I'm meant to create. I was raised by a mother who told me art is a frivolous hobby you do after retirement, although her mother and sister were life-long oil painters. I was the go-to person for drawing the high school mascot, a cowboy on a bucking bronco, on pep rally posters, and I took several live model classes in college. But art became a forgotten pastime as life marched on into marriage after earning a master's degree in communications.

Art resurfaced as a form of self-therapy. I had become a nonworking wife in the seventh year of a failing marriage and had lost a baby I wasn't meant to conceive. I was floundering, lost. The Universe sent me a call to adventure in the form of teaching a public relations writing class at my alma mater that began the next day. I nervously jumped in with both feet. Teaching that summer course led to divorce, earning a doctorate degree, and moving solo from Texas to Connecticut to start life over as a university professor.

During the turmoil of this first life flip, I gravitated to painting female portraits surrounded by emotion and femininity to express the anxiety, fear, determination, and hope I felt. Don't ask me why the female faces ended up on the canvas; that's just what I felt drawn to paint, even though I hadn't created these types of paintings in the past. After the third portrait, I realized I was painting a visual memoir of what was happening in my life one snapshot at a time. It seemed like a private form of self-therapy. Little did I know that a decade later, I'd discover that my memoir portraits were preparation toward building a life based on using my art to inspire others to follow their own life calling.

"If you could be anything in life, no fear, no obstacles, what would that be?" Ten years into my professor position in Connecticut, I began meditating. Deepak Chopra asked what I'd really like to do with my life during a

meditation session, and that's when the Universe blew me away. "An artist" flashed in my mind like a Broadway marquee sign! But I taught public relations. How could I be an artist? It eventually became clear that I needed to flip my life once again. Taking a blind leap of faith into the unknown by quitting my secure, tenured, 12-year professor position scared me to death. The alternative was to allow my soul to suffer. I took the leap.

It's been a winding road that's still unwinding. I ended up moving to Washington State and crafting a life in which my art is woven through each component. I'm writing about artists' creative journeys, hosting a radio show called Unstuck JOY! during which I create an art vision journal page the audience can make at home to help them evolve toward their True Self, and I'm teaching Paint Your True Selfie Portrait art workshops. The Universe has also sent me a crazy idea about writing a stage play based on my memoir portraits and other artists' stories (imagine The Vagina Monologues art style!). We'll see where that spark of inspiration leads!

Intuition, intuition, intuition. The best advice I can give to overcome your creative roadblocks is to become closely acquainted with that little voice that lives inside your heart. Your intuition is connected to your Higher Power; it will never lead you astray. Following your intuition may not always make sense to others in your life. It takes courage to go against society's "norm." Maybe you need to quit a stable job, move to a new location, or end a toxic relationship to evolve into your True Self. Or maybe you just need to carve out "you time" in the calendar one Saturday a month. Tailor it toward your unique circumstances.

I've discovered that your dreams are sent to you from the Universe. When you choose to follow that gut feeling, you'll be given the resources, open doors of opportunity, and people to help you fulfill the next right step. Learn to ask big, because the Universe loves to assist you when you use your gifts to make the world brighter. The trick is to remain in a positive mind space. Remain in an attitude of joy, gratitude and love, because what you focus on and feel are what boomerang back to you.

I've lit my candle; let me light yours. The legacy I hope to leave is that by having the courage to shine my light and use my gifts, others will be inspired to do the same. The world is best served when you allow the artistic super powers you were born with to shine! I hope you will recognize yourself in my memoir portraits and story. We all have a calling, a drumbeat that guides us toward the reason of why we exist. You're not meant to play small, fit into a box that doesn't belong to you, and allow your soul to suffer. You were placed on this planet for a reason. Live it and feel Unstuck JOY! Your soul is whispering artistic, creative somethings in your ear. Are you listening?

www.vickiworldart.com

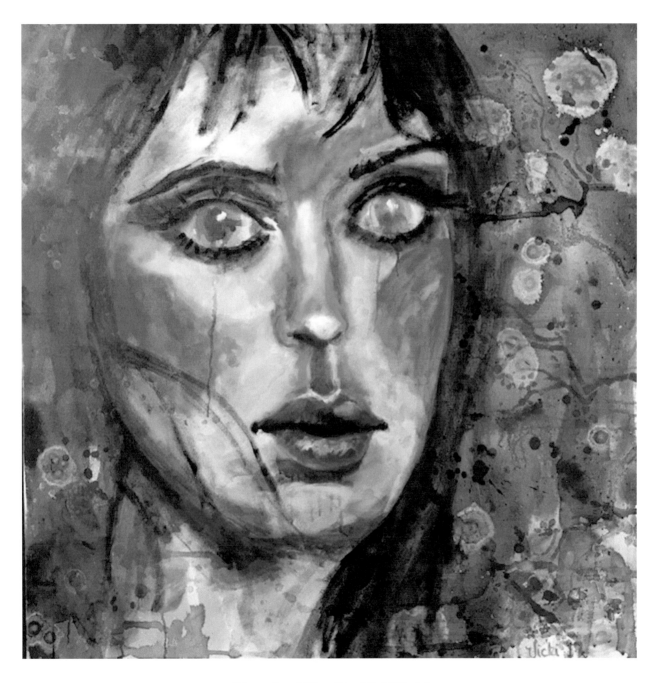

"Honesty of Claud" by **Vicki Todd**

Printed in the United States
By Bookmasters